Part-Time Ink

Pavan Ahluwalia
Photography by Jacqui Melville

Part-Time Ink

CREATE YOUR OWN STYLISH HENNA

DESIGNS AND TEMPORARY TATTOOS

hardie grant books

Contents

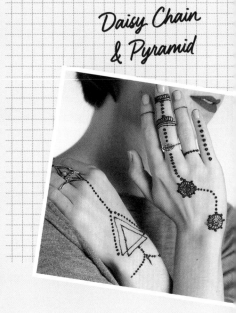

Daisy Chain & Pyramid

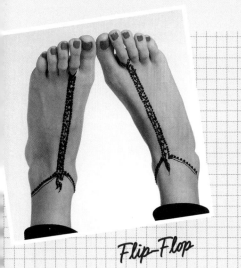

Flip-Flop

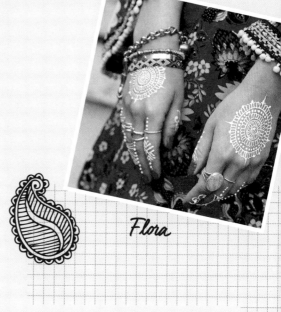

Flora

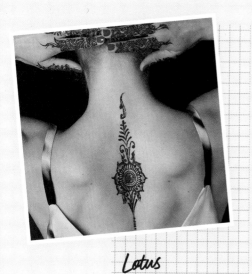

Lotus

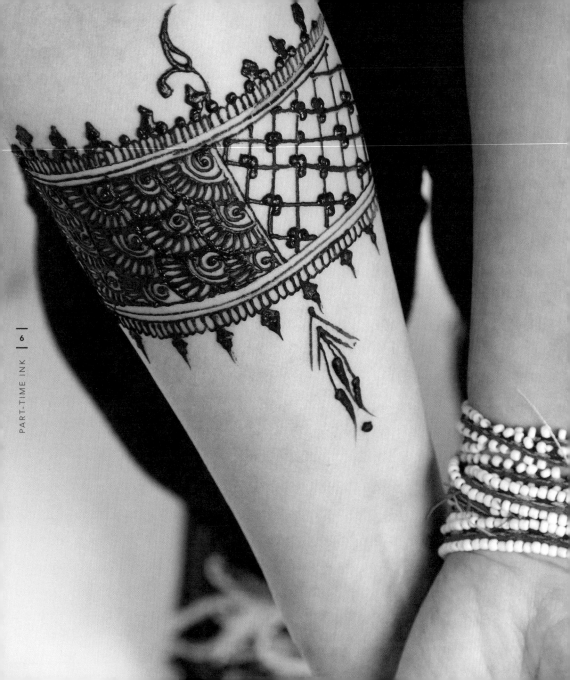

Introduction

This book will help you to create simple and effective henna designs for all occasions.

Learn how to make your own henna cone, add sparkle to your henna with gems and glitter or use body paint and eyeliner to produce fantastic looks. For those who don't mind getting their hands dirty, I even show you how to make your own henna paste (see pages 14–15). I've included 30 unique designs that are easy to replicate. Copy them exactly using a cheat transfer (see pages 18–19) or create your own twist!

At my henna bar at Selfridges, clients are always amazed by how much the world of henna has to offer. Now you can go on your own henna journey at home!

Pavan

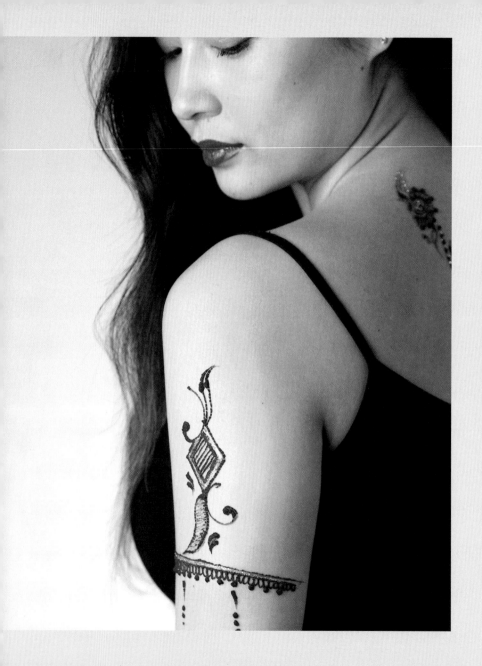

Before you get started...

Henna is so simple once you know the basics.
Read on to find out the tools and techniques
you need to create wonderful designs!

The history of henna

WHAT IS HENNA?

Henna is a plant, grown in hot climates around the world. Henna leaves can be ground into a powder and mixed to create a paste that stains the skin and can be used to make all of the fantastic designs you'll find in this book. At Pavan Henna Bar, we source our own henna powder and mix it with water, clove oil and eucalyptus oil to create our henna paste.

THE HENNA TRADITION

The earliest known use of henna was in Egypt around 5,000 years ago – mummies have even been found with henna designs on their skin! Henna is popular across many countries including India, Pakistan, Bangladesh and Algeria.

Henna was originally used to cool down the skin in hot climates where the plant is grown. Before the delicate designs we know and love today came about, there was no aesthetic aspect to henna – it was smeared onto the body with the fingers rather than using any special tools.

Traditionally, henna is worn on the hands and feet, but why stop there? Henna looks so wonderful all over the body!

MODERN HENNA

Weddings are traditionally the reason for applying henna. The bride's hands and feet are adorned with intricate designs that match the embroidery of her beautiful outfit. Henna is also often worn on special occasions like Diwali, Eid and New Year.

My clients often visit before going on holiday, going to music festivals like Glastonbury or attending Christmas parties. But henna can be worn throughout the year. There doesn't need to be any special reason – apart from wanting to add a touch of glamour to your day.

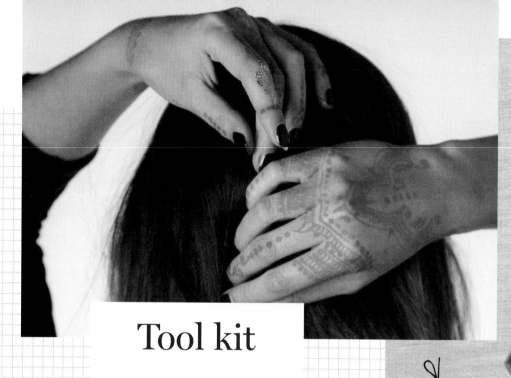

Tool kit

The great thing about henna
is you really don't need
many tools. I suggest you
always have the following:

1. A filled henna cone.
You can buy mine at
www.pavanonline.com,
or even make your own
(see pages 14-15).

2. Glitter cones or gems.

3. A damp cloth to clean up
any mistakes that occur.

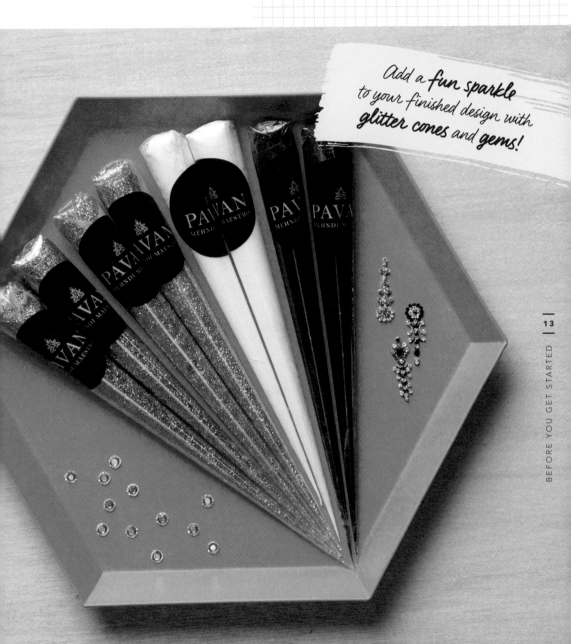

Add a *fun sparkle* to your finished design with *glitter cones* and *gems!*

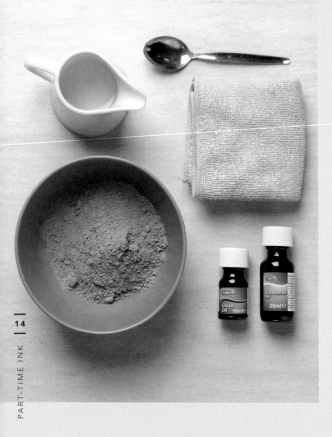

Important: Make sure you avoid any henna labelled as 'black henna' or with a chemical smell. Natural henna is made only from plants, but black henna contains harmful chemicals that can damage your skin.

MIXING UP YOUR HENNA PASTE

YOU WILL NEED

250 ml (8 fl oz) water
250 g (8 oz) henna powder
50 ml (1½ fl oz) eucalyptus oil
25 ml (1 fl oz) clove oil

HOW TO

1. Add the water to the henna powder and stir to create a thick paste.
2. Add the oils and keep mixing until the paste is smooth and ready to fill your henna cones.
3. Store your henna in a sealed container in a cool, dark place or if possible, in the freezer.

Henna paste and cones

We sell our own brand of henna powder at Pavan Henna Bar or online at **www.pavanonline.com,** but it is easily sourced at most Indian grocery stores.

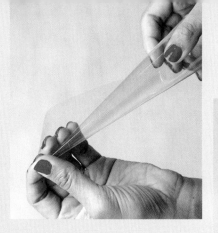

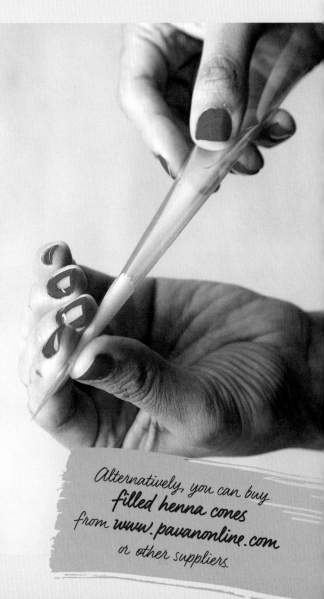

MAKING YOUR
HENNA CONE

YOU WILL NEED

sheet of cellophane
clear tape
scissors
henna paste

HOW TO

1. Cut out a rectangle of cellophane (buy from craft shops or use flower paper or freezer bags) and fold into a cone shape, then secure with tape.

2. Snip the tip off the cone, cutting around 3 mm (⅛ in) from the tip. The further up the cone you cut, the thicker the line.

3. Pour your henna paste into the cone and seal at the top with clear tape.

Alternatively, you can buy *filled henna cones* from *www.pavanonline.com* or other suppliers.

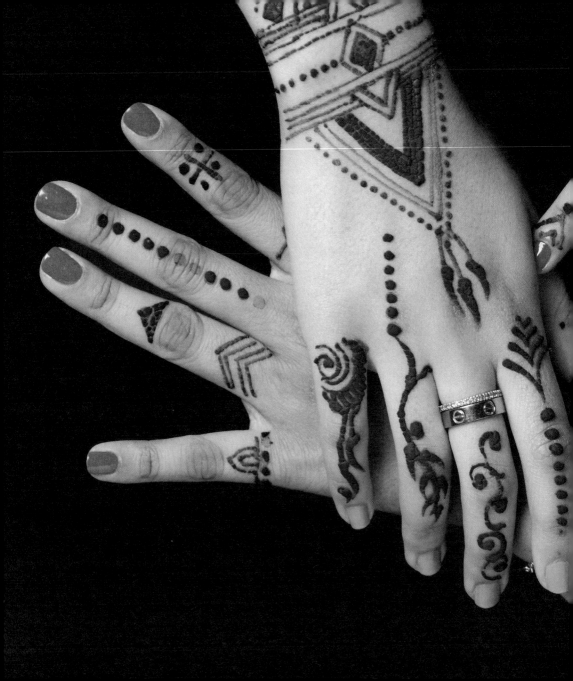

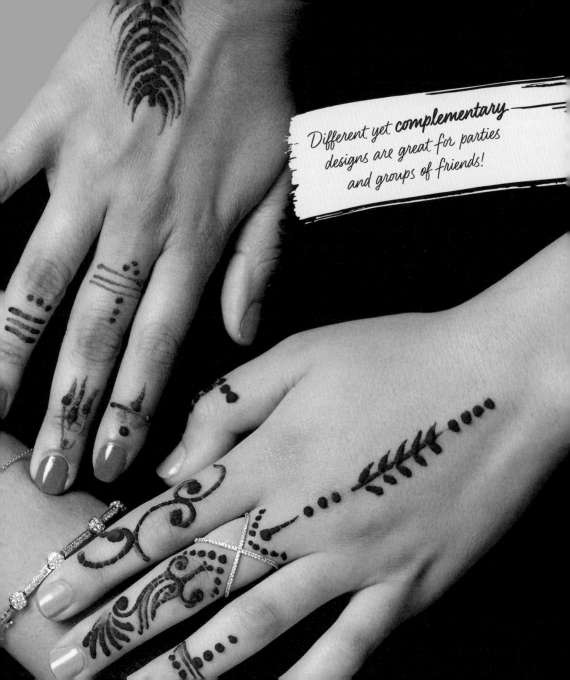

*Different yet **complementary** designs are great for parties and groups of friends!*

How to do a cheat transfer

This is a great way to get the more complicated designs onto your body without the hours of practice!

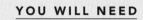

PART-TIME INK

2

YOU WILL NEED

sheet of paper

printed design from the book (just photocopy any one you like)

black biro pen

scissors

clear deodorant stick

1

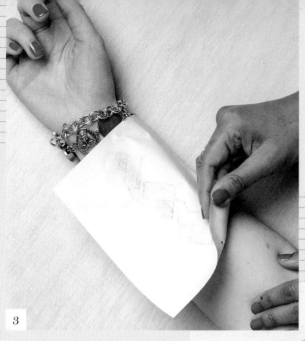

3. Slowly remove the paper.

4. The outline of the design should appear on the skin. Trace over the outline with henna, eyeliner or body paint.

3

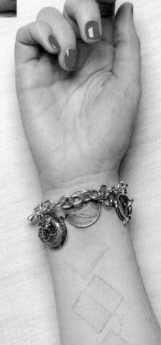

4

HOW TO

1. Place the piece of paper over the printed design and trace over with the pen, then cut out the design with scissors.

2. Apply a layer of deodorant to the area where you wish to apply the tattoo and place the design on the skin, holding and applying pressure for a few seconds.

The design elements

To get kick-started, here are five simple design elements to work with. These can be used on their own or combined to make a more elaborate piece. Becoming familiar with them is the first step to creating your own henna designs.

Tip: Layer **straight lines** with **dots** to create popular angular designs.

1. PAISLEY

This is quite an easy shape, and the outline can be applied anywhere – the wrist, shoulder, back of the hands… It can even be the main motif in intricate bridal henna. There are also many ways to fill in this shape, using a shading technique, small swirls or block colour.

2. SCALLOPED FAN

This is a great starting point for designs. Simply start with a dot in the centre and work outwards, finishing off with scalloped U-shapes.

3. SWIRL

You can't go wrong with a swirl! These can be used to fill in bigger shapes or to connect two motifs together to keep the design consistent.

4. LEAF

This shape can be shaded in or filled with swirls, and is another great way to connect designs.

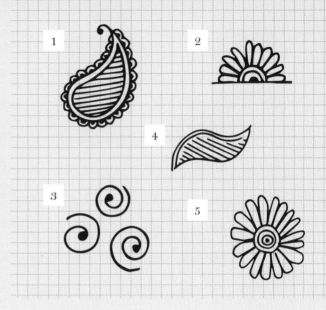

5. FLOWER

Who doesn't love a flower in their henna designs? These are really easy to do. Start from the centre and work your way outwards, making the petals as big and bold or tiny and delicate as you wish.

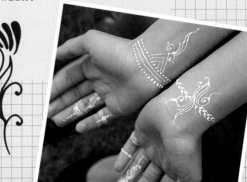

Tips for amazing henna

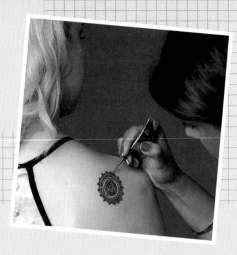

APPLYING YOUR HENNA

The key to great henna application is a steady hand! Practice on paper before applying to your skin to get the feel of your henna cone. Make sure the henna cone touches the surface on which you are applying at all times, just like pen to paper.

No matter what design you're creating, always follow these tips when using henna:

1. Wash the skin with soap and water and dry thoroughly before applying your henna.

2. Use a transfer for more difficult designs – find out how on pages 18-19. It's a great way to get your confidence up.

3. Snip the tip off the henna cone, roughly 3 mm (⅛ in) up the cone.

4. Hold the cone like a pen and rest on the skin to slowly create the designs.

Squeeze gently to avoid any big splodges of henna.

5. On intricate, circular designs, always work from the centre outwards.

6. For designs on the arm, start from the wrist and work towards yourself.

7. Leave the henna to dry on the skin for at least 20 minutes, longer if possible, and crumble off naturally. Never wash your henna off with water! The longer you leave the henna and the warmer your skin, the darker your design will be.

8. Henna stains darken with time and will take 48 hours to fully develop.

TAKING CARE OF YOUR HENNA

Henna usually lasts for 10-14 days, as long as you take care of it properly. On the day of application, keep your skin as dry as possible, as any water could wash away the oils. Try not to rub the design too much. Chlorine, salt water, household cleaning products, hand sanitiser and scented body lotion are also best avoided for long-lasting henna designs.

If you wish, you can use a special henna aftercare balm to help the henna last for longer. Buy from henna stockists, or try a pot of Burt's Bees lip balm. Make sure you don't use any petroleum-based products such as Vaseline, as this can make the stain disappear faster.

If you want to remove your henna designs faster, gentle exfoliation can help. You do need patience as the dye fades naturally.

No matter how experienced you get or how intricate your designs become, these tips are always useful!

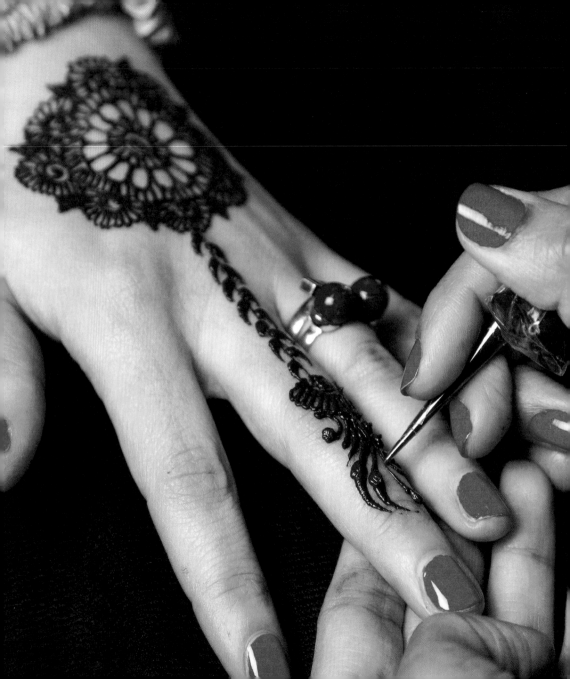

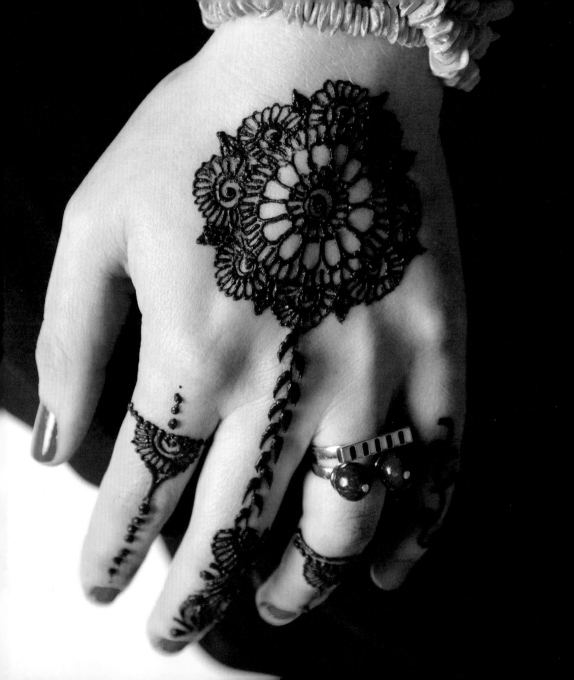

Alternatives and extras

ALTERNATIVES

Many of the designs in this book don't require henna, as they can also be drawn using other materials. This is especially great if you want to wash your henna off easily – perfect for when you're practising or if you want a dramatic design for a festival or party!

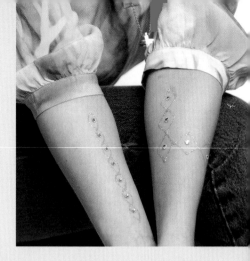

I love using MAC Paint Pots – highly pigmented creams which are often used as eyeshadows, but can also be used with a brush to create amazing body art designs. There are so many vibrant colours to choose from that will really make your designs pop.

Liquid eyeliner is another fantastic henna alternative – brown and white colours look especially wonderful on the skin. Illamasqua is my favourite brand but you can use whatever you have in your make-up bag!

You can now also buy coloured gel tattoo pens, which are so easy to use.

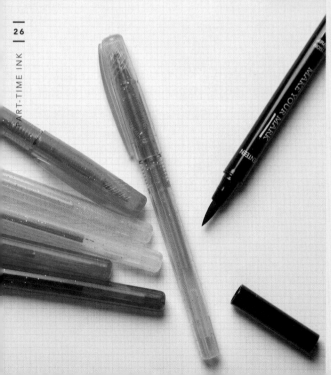

EXTRAS

Add extra sparkle to your henna using stick-on gems and diamantes. Plan your designs and add the gems when the henna is dry. For nights out, festivals or parties, why not use glitter henna, available at **www.pavanonline.com** or all good henna stockists?

Really, the possibilities are endless – stick-on gems, diamante designs, stickers… let your imagination take your henna to new heights.

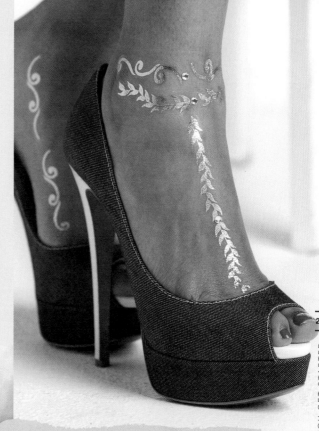

Use *metallic henna tattoos* for nights out, festivals or parties!

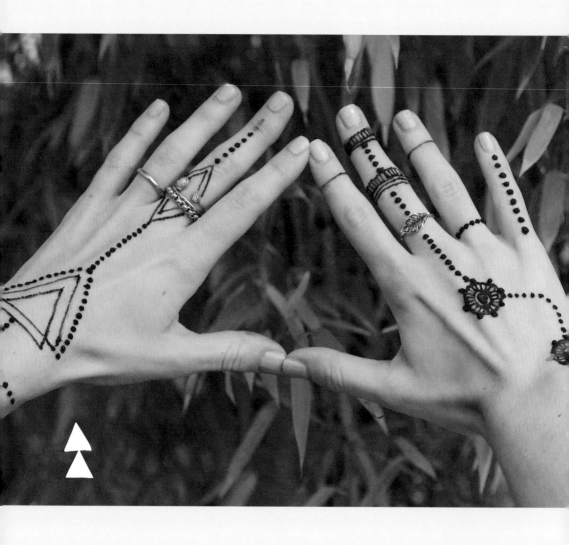

The henna tutorials

30 henna designs ranging from easy to difficult to help you create fantastic looks and hone your skills.

TUTORIAL SKILL LEVEL

Easy ▽ Moderate Difficult

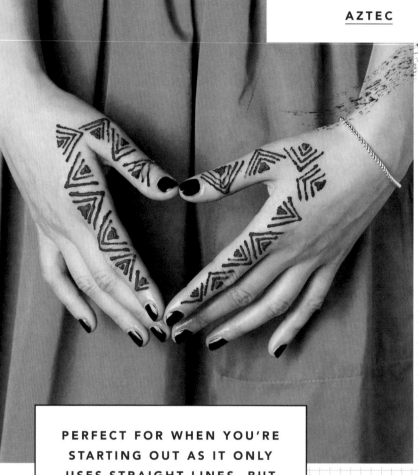

Nº 1

AZTEC

PERFECT FOR WHEN YOU'RE STARTING OUT AS IT ONLY USES STRAIGHT LINES, BUT STILL HAS A DRAMATIC IMPACT

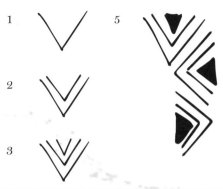

1

2

3

5

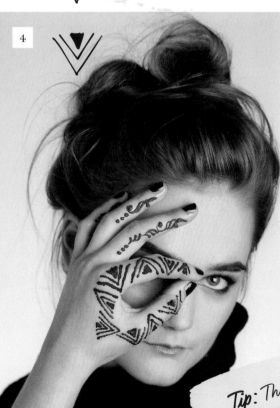

4

HOW TO △

This Aztec design is so simple and effective!

1. Draw a V-shape across the top of the thumb.

2. Draw a smaller V-shape within the first shape.

3. Draw a triangle within the second shape.

4. Finish by filling in the triangle with henna.

5. Repeat steps 1-4 along the thumb and index finger, alternating between V-shapes and upside-down V-shapes to make an amazing Aztec pattern!

Tip: This design works by following the shape of the finger and thumb, so make sure you don't make your triangles too big.

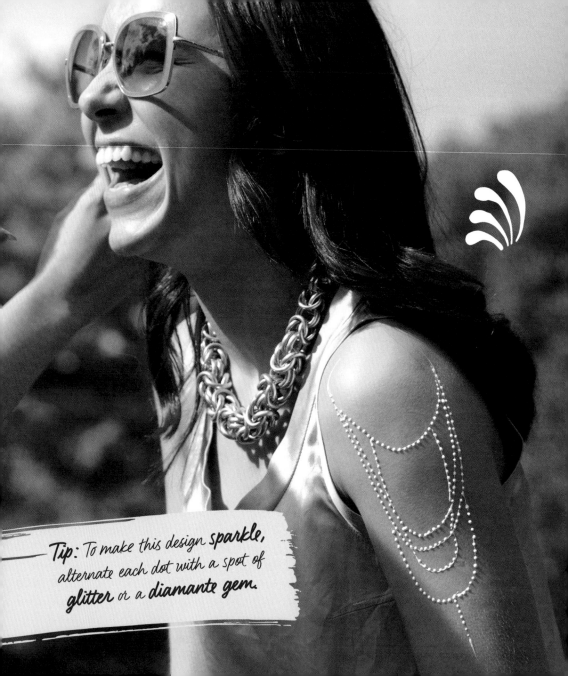

Tip: To make this design **sparkle,** alternate each dot with a spot of **glitter** or a **diamante gem.**

Nº 2

CHAINS

HOW TO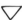

A super simple design, low maintenance and great for festivals. You can easily use eyeliner or UV body paint so you can really glow at Glastonbury.

1. Using evenly spaced dots, create a chain shape, looping around the shoulder.

2. Follow the line to make another, longer chain, again looping around the shoulder but finishing lower down the arm.

3. Repeat as many times as desired, overlapping chains to create a gorgeous design.

1

2

3

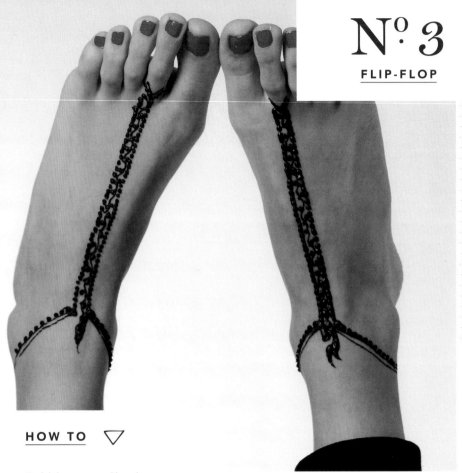

PART-TIME INK

HOW TO ▽

Holiday paradise!

1. Draw a V-shape at the base of the second toe. Draw a line of dots from the base of the V-shape on the left-hand side, running all the way down to the ankle.

2. Draw another line of dots running down from the base of the V-shape on the right-hand side, leaving a 1 cm (½ in) gap between the two dotted lines.

3. Draw a squiggly trail between the two dotted lines: bring the cone down to create a dot then lift up slightly to create a thin, squiggly line. Repeat all the way down the foot.

4. Draw a line of dots extending from the bottom of the dotted lines around the ankle.

5. Outline the ankle with a solid line and draw tassels in the centre of the ankle at the base of the design.

Nº 4

NECKLACE

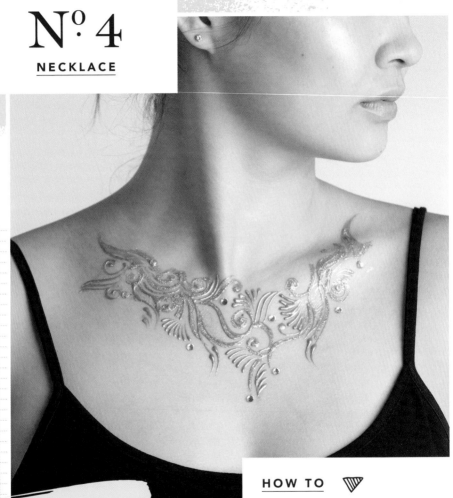

Tip: The best henna designs echo the **natural** **curves** of the body.

HOW TO

This gorgeous look is a subtle way to use glitter henna - ideal for formal events.

1. Beginning at the collarbone, draw swirls and flourishes down towards the chest.

2. Extend down to the sternum, adding swirls and embellishments and filling in gaps with light shading.

3. Continue drawing swirls up the collarbone, making the design even or asymmetrical depending on your preference. Finish by adding stick-on gems.

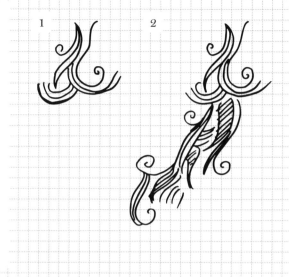

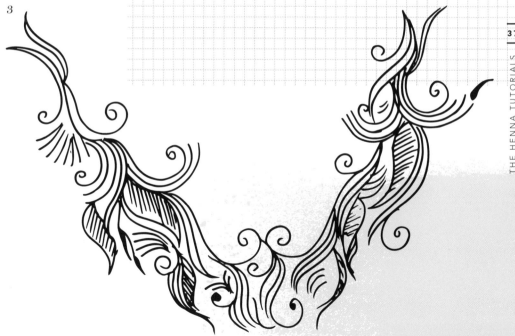

THE HENNA TUTORIALS

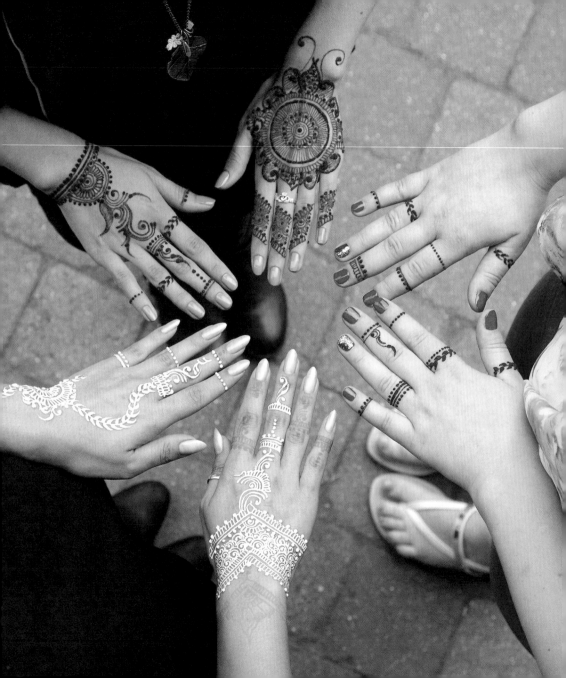

N.º 5

RINGS

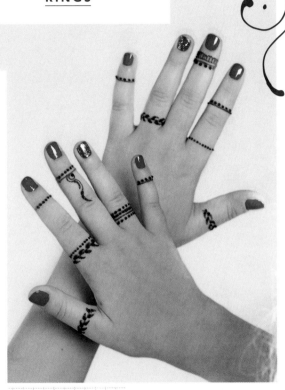

HOW TO ▽

Rings are one of my henna saviours! They can be worn alone or added to almost any design to give more detail and interest. They're also a fantastic way to practice your control over a small area and build your skills.

On this page you'll find a great selection of ring designs to copy and take inspiration from. You'll be creating your own gorgeous designs in no time! Swirls, dots, petals… the choice is yours.

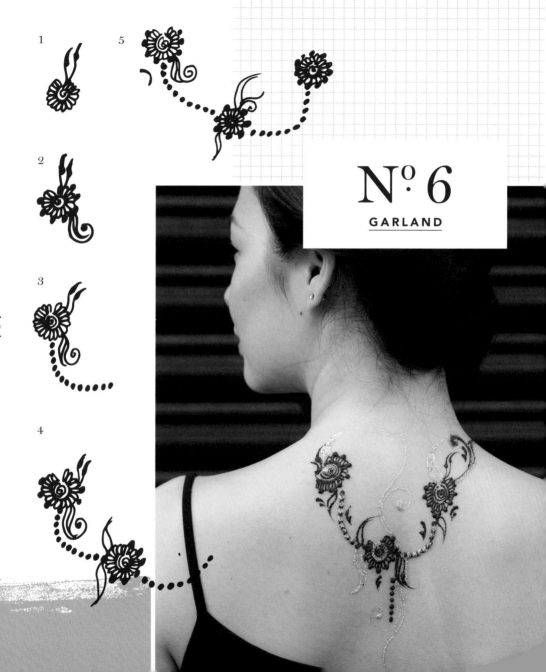

1

2

3

4

5

Nº 6

GARLAND

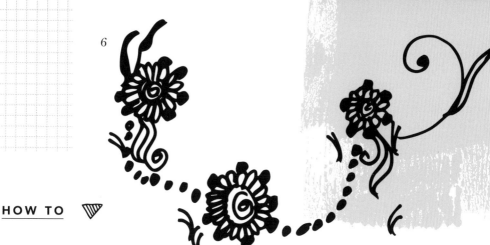

6

HOW TO

The asymmetry makes this design so sophisticated and beautiful. At my henna bar, lots of people request this garland for a party or special event as it adds glamour to any look.

1. Begin with the flower at the top, on the left-hand side of the neck. Draw the central swirl of the flower, then surround with a semicircle of petals.

2. Add swirls and leaves to the flower.

3. Draw a trail of dots leading down and to the right, towards the centre of the back.

4. Before you quite reach the centre, draw another flower using steps 1–2.

Draw a trail of dots from the second flower, leading up the back and to the right.

5. Before you quite reach the level of your first flower, draw a third flower using steps 1–2.

6. Add flourishes, dots and more leaves if desired.

If using glitter henna or body paint, add to the dots, leaves and centres of the flowers, then add some extra leaves and swirls in gold.

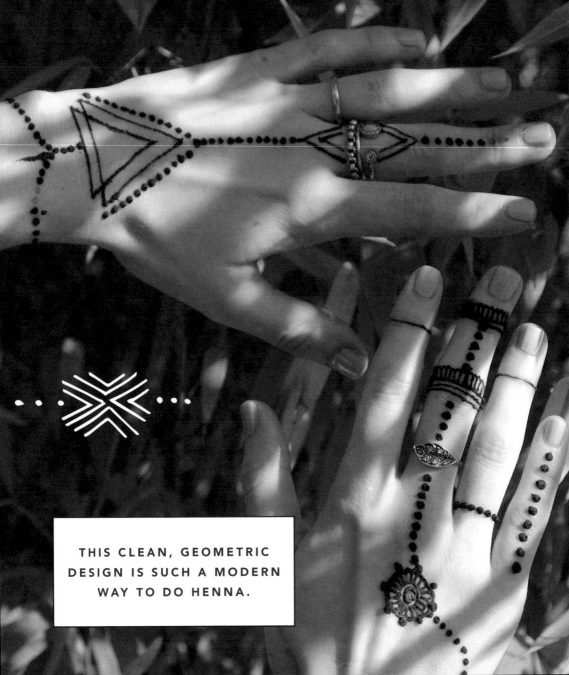

THIS CLEAN, GEOMETRIC DESIGN IS SUCH A MODERN WAY TO DO HENNA.

N⁰ 7

PYRAMID

HOW TO ▽

A great design for a fashion-forward look, which shows that henna doesn't always have to be delicate or flowery! Be bold!

1. On the back of the hand, draw two overlapping triangles using solid lines.

2. Create a band across the wrist using small dots, spaced very close together. Draw a small vertical line of dots up towards the hand.

3. Draw two lines of dots on either side of the largest triangle. At the point of the largest triangle, draw a line of dots, extending across the hand in a straight line towards the base of the middle finger.

4. Draw a small diamond shape at the base of the middle finger, then outline with a larger diamond, connecting to your line of dots.

5. Complete the look by extending the line of dots across the middle finger.

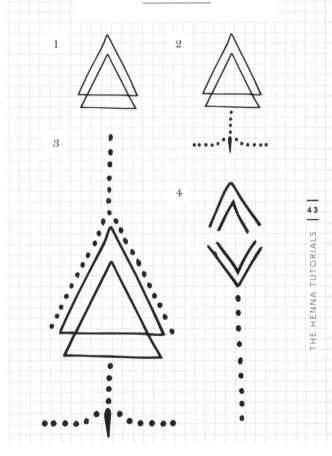

THE HENNA TUTORIALS

1 **2** **3**

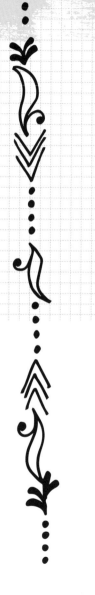

HOW TO ▽

Sleek, minimal, chic…
and easy! This design
has it all.

1. Begin at the point
of the arm where you'd
like the vine to begin,
and draw three or four
dots in a line.

2. Extend the vine down the
arm using dots, arrows
and swirls, moving down
towards the little finger.

3. Continue the design
all the way down the little
finger – a combination
of swirls and bold dots
works wonderfully.

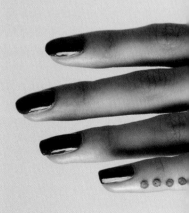

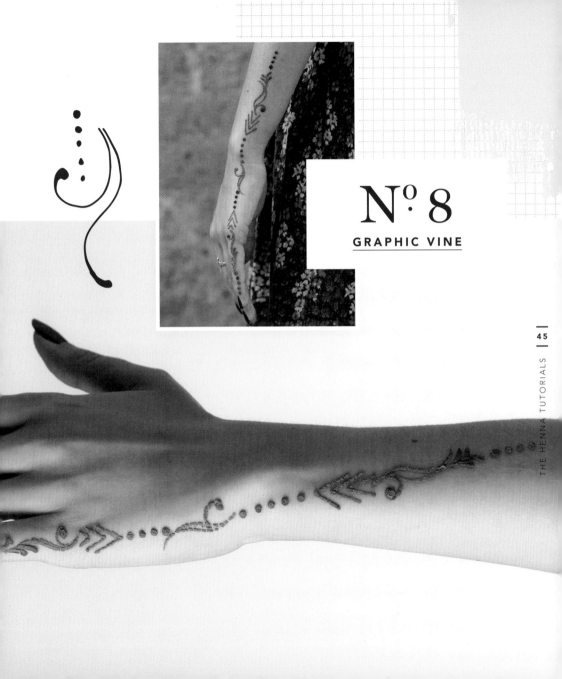

Nº 8

GRAPHIC VINE

HOW TO

This is one for all the free spirits and flower girls! Feel free to extend the chain around the wrist or add leaf and petal shapes to feel even more at one with nature.

1. Just above the wrist, draw a small swirl and outline with a circle. Draw petals around the circle to create the centre of the daisy.

2. Draw a circle around the petals. Line with dots at equal intervals to complete the daisy.

3. Create a curling trail of dots up towards the centre of the hand.

4. Draw another daisy, following steps 1-2. Continue the trail of dots up onto the middle finger.

5. To finish, decorate the fingers with rings, lines and dots.

1 2 3 4 5

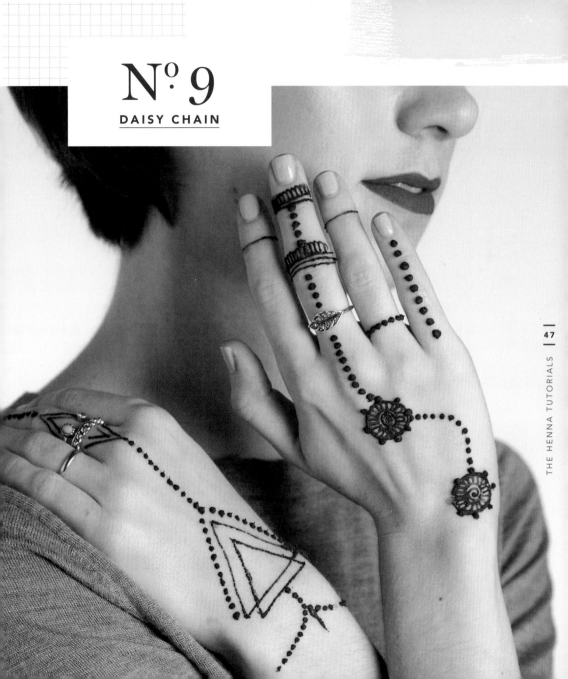

№ 9

DAISY CHAIN

Nº 10

WHISPER

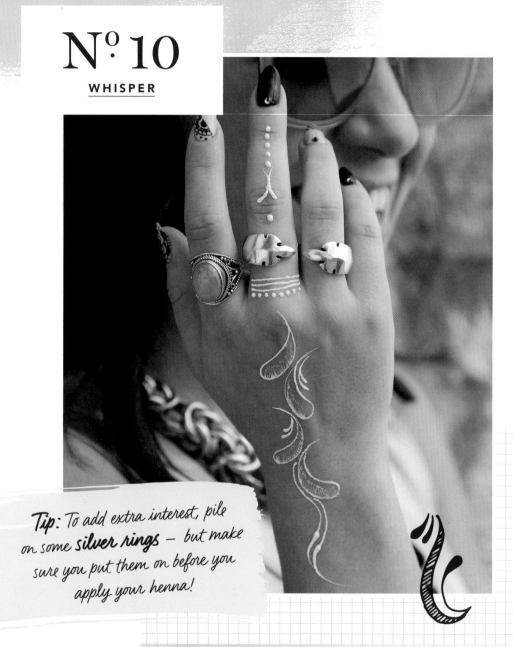

Tip: To add extra interest, pile on some **silver rings** — but make sure you put them on before you apply your henna!

HOW TO ▽

This delicate design gives a subtle finish to any outfit. The soft, feathery paisley shapes contrast beautifully with the geometric design on the finger.

1. Starting at the wrist, draw loose paisley shapes leading down towards the base of the middle finger. Use a delicate touch and follow the natural curve of the hand.

2. Shade in the paisley shapes with very light strokes to create depth.

3. Draw rings on the middle finger and continue up the finger with dots and curved arrows to complete the look.

1 2 3

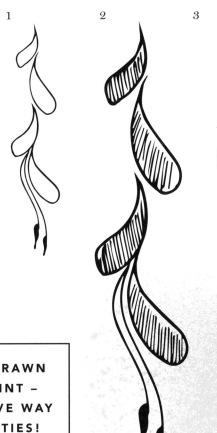

> **THIS DESIGN CAN BE DRAWN WITH WHITE BODY PAINT – A SIMPLE AND EFFECTIVE WAY TO STAND OUT AT PARTIES!**

1 2 3 4 5

 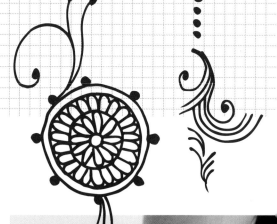

HOW TO

You might not be able to predict the future but at least you can be sure that this design will look fantastic!

1. Begin by drawing a small circle, roughly in the centre of the palm. Draw scalloped U-shaped petals around this centre, then outline with another circle.

2. Extend your design by repeating step 1, then outline the whole flower with another circle to create your mandala.

3. Place large, equally spaced dots around the mandala.

4. Draw swirls and dots extending down towards the base of the palm and up towards the ring finger.

5. Complete the design by drawing flowing swirls across the ring finger.

PART-TIME INK

Nº 11

PALMISTRY

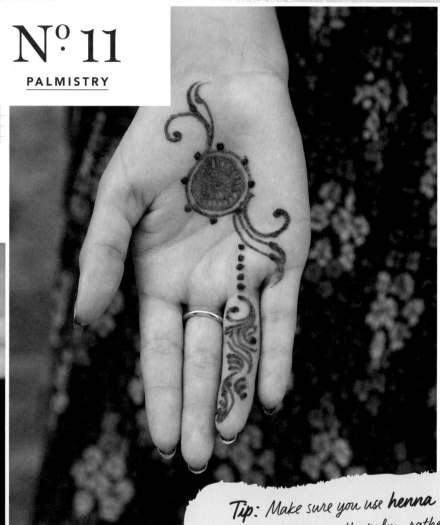

Tip: Make sure you use **henna** for any designs on the palm, rather than eyeliner or body paint, to avoid it rubbing off.

№ 12

CHARMED

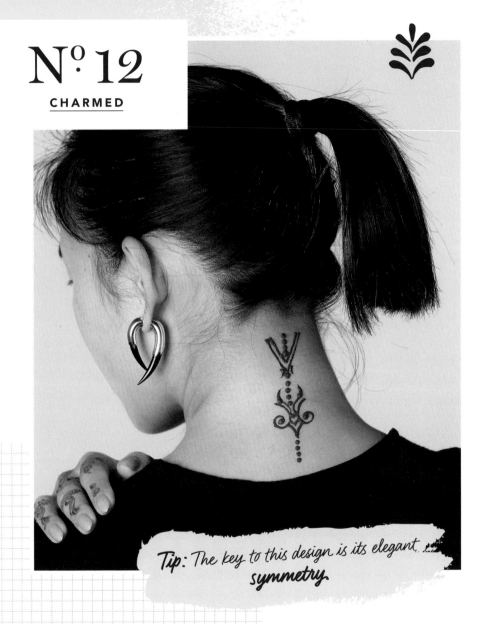

Tip: The key to this design is its elegant symmetry.

HOW TO ▽

This neck piece looks fabulous whether you're rocking a pixie cut or an updo. It's both glamorous and edgy.

1. Create a double V-shape at the nape of the neck.

2. Draw small dots down the centre of the V-shape, then continue with a trail of four dots below.

3. Create a small, symmetrical shape below the dots using swirls, petals and arrows.

4. Finish by continuing the trail of dots down to the base of the neck.

1

2

3

4

THE HENNA TUTORIALS

№ 13

PATCHWORK

Tip: For a unique design, play around with the **patterns** and **shapes** you use to fill in the squares.

1 2

3 4

HOW TO

This design effectively combines bold shapes with intricate patterns.

1. Draw a large diamond shape just below the wrist. Draw a smaller diamond within the larger one, taking up just over a quarter of the shape.

2. Fill in the smaller diamond with swirls.

3. Draw straight lines across the top-right corner of the diamond.

4. Draw straight lines in the opposite direction, filling in the diamond.

5. Draw two more diamonds further along the hand and fill in by repeating steps 1-4. Connect the diamonds

with a trail of dots, leading across the hand and up the middle finger.

6. Add V-shapes to the base of the middle finger.

THE HENNA TUTORIALS

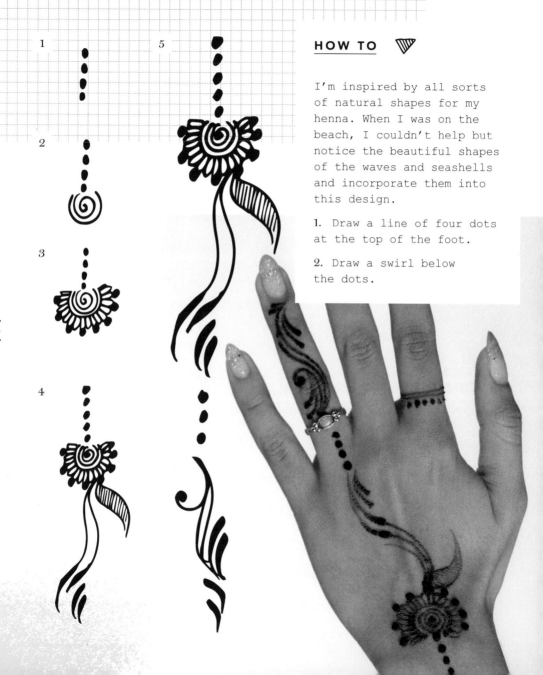

1

2

3

4

5

HOW TO

I'm inspired by all sorts of natural shapes for my henna. When I was on the beach, I couldn't help but notice the beautiful shapes of the waves and seashells and incorporate them into this design.

1. Draw a line of four dots at the top of the foot.

2. Draw a swirl below the dots.

3. Outline the swirl with a semicircle of scalloped U-shaped petals, creating a fan. Draw equally spaced dots around the petals.

4. Draw leaf and petal shapes extending up the top of the foot.

5. Draw a line of four dots extending up towards the second toe. At the base of the second toe, draw more swirls, leaf and petal shapes.

Tip: Finish off with diamante gems and draw toe rings if you wish.

Nº 15

STACKED BANGLES

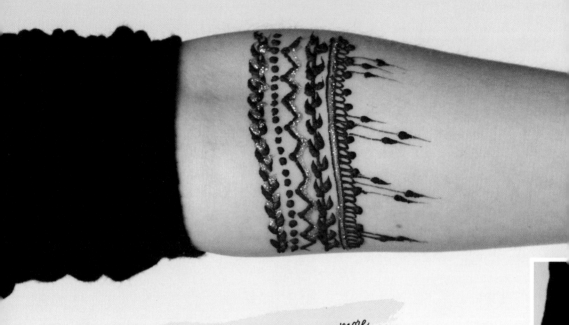

*Tip: Make this design even more fabulous with **pops of gold.***

HOW TO

This bangle design is so easy to personalise – you can even draw your favourite bracelets on your arm!

1. Draw a band of petals across the arm just below the elbow, carefully controlling the pressure of the henna cone.

2. Below the band, draw a line of dots across the arm.

3. Below the dots, add a zigzag across the arm.

4. Working downwards, create another band of petals.

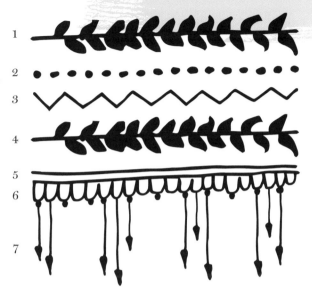

5. Draw two thin lines next to each other, just beneath the last band you drew.

6. Add a scalloped design of looping U-shapes under the straight line. Add equally spaced dots beneath the scalloped edging.

7. Finish off with some lines trailing from the bangles, ending in delicate arrow shapes.

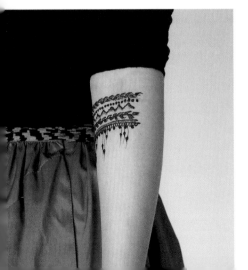

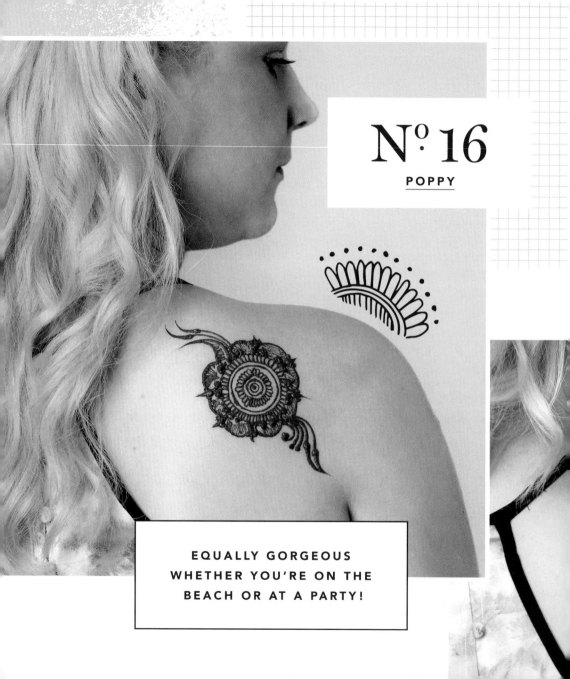

Nº 16

POPPY

EQUALLY GORGEOUS WHETHER YOU'RE ON THE BEACH OR AT A PARTY!

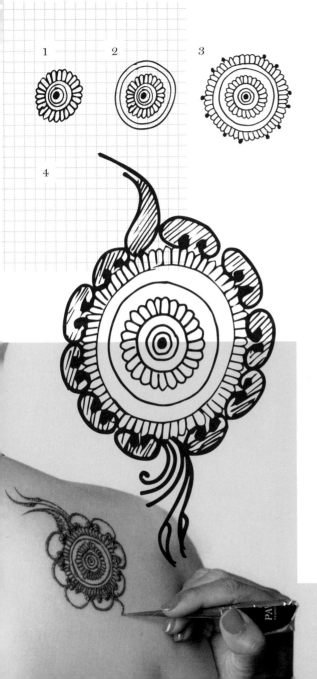

HOW TO

This design is definitely for the summertime, when you can show off some skin!

1. On the base of the shoulder, draw a dot and outline with three small circles. Draw scalloped U-shapes around the outer circle to create the centre of the mandala.

2. Draw two more concentric circles around the design.

3. Draw a ring of scalloped U-shaped edging around your mandala, then outline with equally spaced dots.

4. Join the dots with a curved line and shade in. Draw two sets of swirls and lines extending outwards from your mandala – one pointing up towards the neck and one down towards the arm. To complete, add small points to the dots around the edge of the mandala.

1

2

3

4

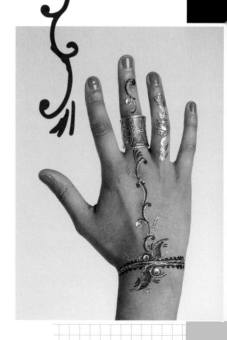

HOW TO ▽

I love this beautiful bracelet design – it's so simple to do too!

1. Draw a bracelet of three closely spaced lines across the wrist.

2. Line both sides of the bracelet with dots.

3. Create swirling motifs on either side of the bracelet using leaf shapes.

4. Continue the swirl pattern up to the middle finger and add the petal-chain detail to the ring finger. Add extra embellishments using glitter henna and gems.

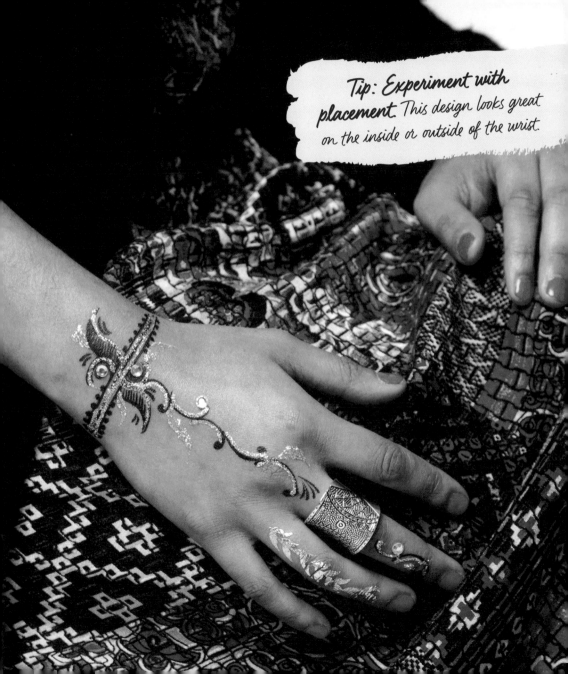

Tip: Experiment with placement. This design looks great on the inside or outside of the wrist.

Nº 18

DREAMCATCHER

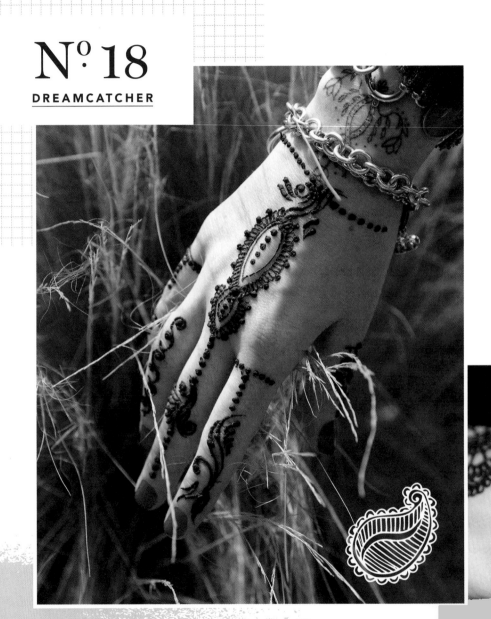

HOW TO

Dare to dream!

1. Create a horizontal line across the wrist using dots. Draw small swirls leading down the hand.

2. Draw a leaf shape in the centre of the hand and outline with scalloped U-shapes. Outline the shape with dots and draw a line of dots down the centre.

3. Draw a smaller leaf shape below the first and add the scalloped edging and dots.

4. Use dots to lead onto the middle finger. Draw swirls when you reach the knuckle, then continue the trail of dots.

5. Decorate the other fingers with swirls, dots and rings.

1

2

3

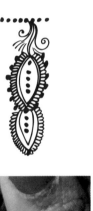

4

5

Nº 19

TEXTILE

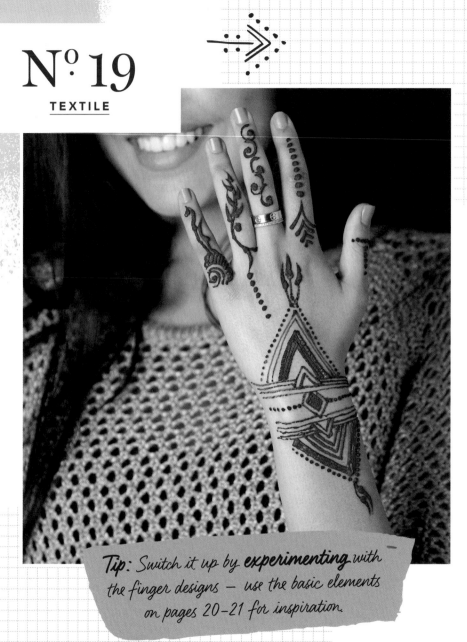

Tip: Switch it up by *experimenting* with the finger designs — use the basic elements on pages 20–21 for inspiration.

HOW TO

It's not just nature that inspires me – this design came into my head when I was wearing one of my favourite scarves! The patterns and textures of fabric offer great ideas for new designs.

1. Draw a small diamond, roughly in the centre of the wrist, and fill in. Outline with a larger diamond.

2. Draw a small triangle above and below the diamond. Draw lines either side of each triangle, extending horizontally to create a band across the wrist. Add a line of dots on either side of the small diamond.

3. Draw V-shapes behind each triangle, extending outwards to create a scarf-like pattern. Fill in some of the V-shapes to create solid lines.

4. Draw dotted lines to surround the triangular shapes. Add tassels to the points of both triangles, extending up and down the wrist.

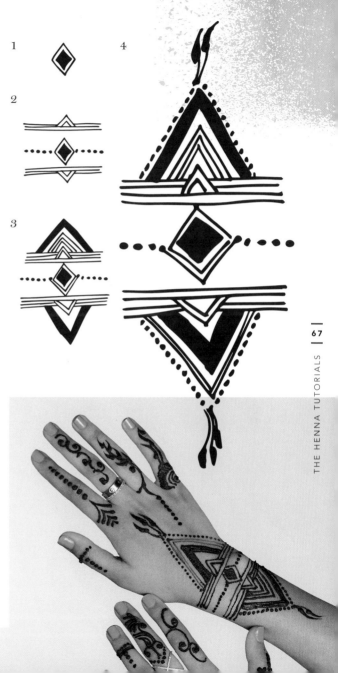

THE HENNA TUTORIALS

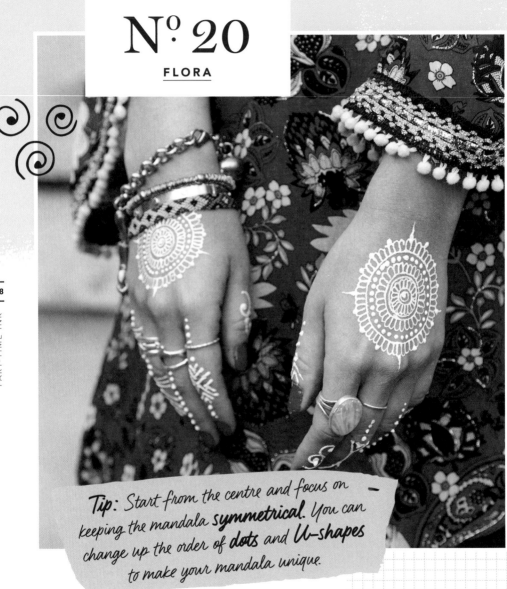

Nº 20

FLORA

Tip: Start from the centre and focus on keeping the mandala **symmetrical**. You can change up the order of **dots** and **U-shapes** to make your mandala unique.

HOW TO ▼

This pretty design is great for festivals. Take inspiration from the shapes of your favourite flowers!

1. Begin with a dot in the very centre of the hand. Draw a circle around the dot.

2. Draw scalloped U-shaped petals around the circle, working outwards. Draw another circle around the petals.

3. Draw more scalloped U-shaped petals around the circle.

4. Decorate with a circle of dots. Outline the dots with another large circle.

5. Complete the mandala with more scalloped U-shapes, dots and compass points.

6. Draw any designs you wish on the fingers – I like to keep them bold and simple to contrast with the detailed mandala.

WHITE BODY PAINT BRINGS A FRESH, MODERN FEEL TO ALL HENNA DESIGNS – I LOVE IT!

N⁰ 21

PEACOCK

HOW TO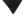

This design is a real statement – you'll definitely be the centre of attention! The swooping lines really complement the shape of the arm and the way the design extends both up and across adds loads of interest to the eye.

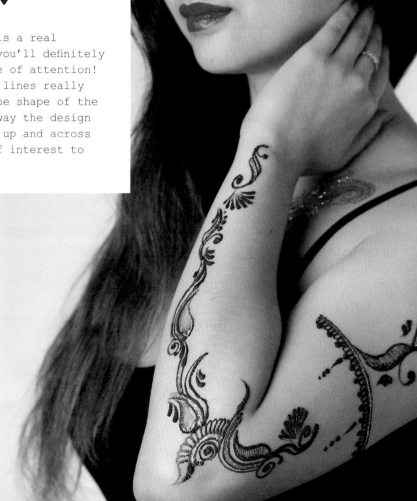

1. Beginning from the wrist, draw swirls, paisley shapes and flowing lines up towards the elbow.

2. At the elbow, carefully draw a scalloped fan shape, beginning by drawing a swirl at the crook of the arm followed by scalloped U-shaped petals.

3. Continue the swirls from the fan up to the upper arm, stopping roughly 10 cm (4 in) above the elbow.

4. Draw a long horizontal line 5 cm (2 in) above the swirls. Draw scalloped edging below it and decorate with dots. Extend two trails of dots towards the swirls.

5. Complete your design by extending swirls from the horizontal line, ending with a diamond shape.

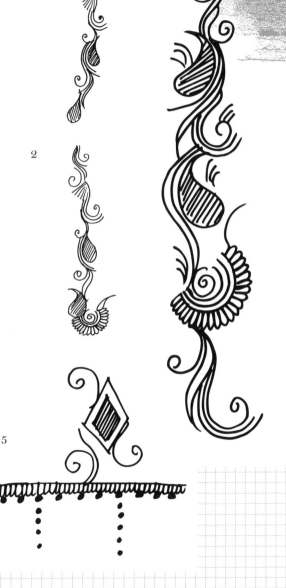

1

3

2

4

5

THE HENNA TUTORIALS

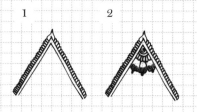

1 2 3 5

HOW TO ▼

This look is pretty
but sophisticated, and
great to push your skills
by combining the slightly
more difficult designs
with simpler shapes.

1. Draw a large V-shape
above the wrist, with the
point towards the fingers.
Draw scalloped U-shapes
along the outer edge of
the V-shape.

2. In the dip of the
V-shape, draw small
semicircles and petals,
moving outwards to create
a fan shape.

3. Draw two more V-shapes
further down towards the
hand, leaving roughly
4 cm (1½ in) between each
V. Draw U-shapes along the
two new V-shapes to create
scalloped edging, as in
step 2.

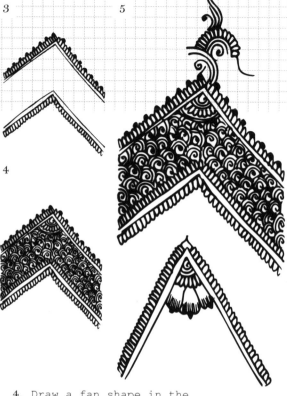

4

4. Draw a fan shape in the
dip of the V-shape closest
to the hand, as in step 2.
Fill in the gap between
the two V-shapes closest to
the hand using swirls.

5. Create a trail of
semicircular swirls and fans
up towards the middle finger.

6. Decorate all of the
fingers with rings, dots
and swirls.

Nº 22

LACE

6

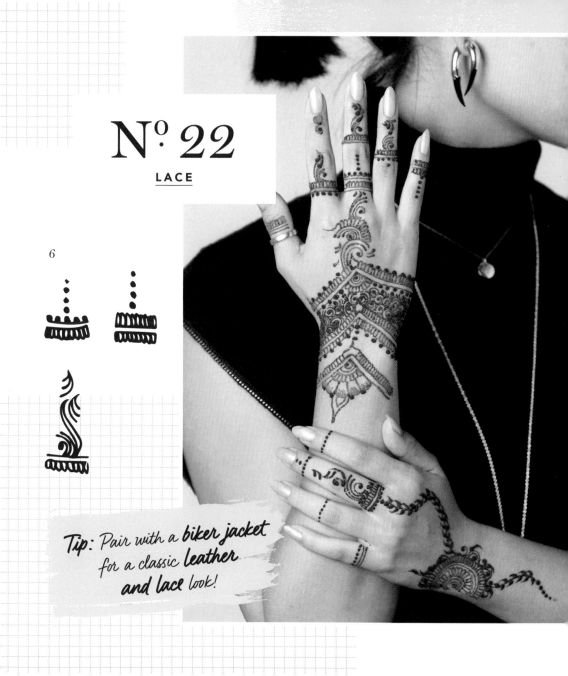

Tip: Pair with a *biker jacket* for a classic **leather** and **lace** look!

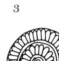

2

HOW TO

This design is perfect for a night out – it looks great with a backless dress, and the lotus is supposed to bring good luck!

3

1. Begin by drawing a small swirl in the centre of the back. Draw scalloped U-shapes extending from the swirl to begin creating the inner ring of your mandala.

2. Draw a circle around the edges of the U-shapes. Outline with a second circle.

3. Draw another set of scalloped U-shapes around the design and outline with two more circles.

4. Draw petal shapes extending outwards from the circle to create your lotus, making sure the design is symmetrical.

4

5. Extend the shape at the top and bottom of the flower using swirls and arrows, following the line of the spine. Add extra swirls and dots to finish off the design. Time to show it off!

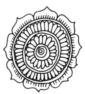

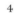

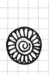

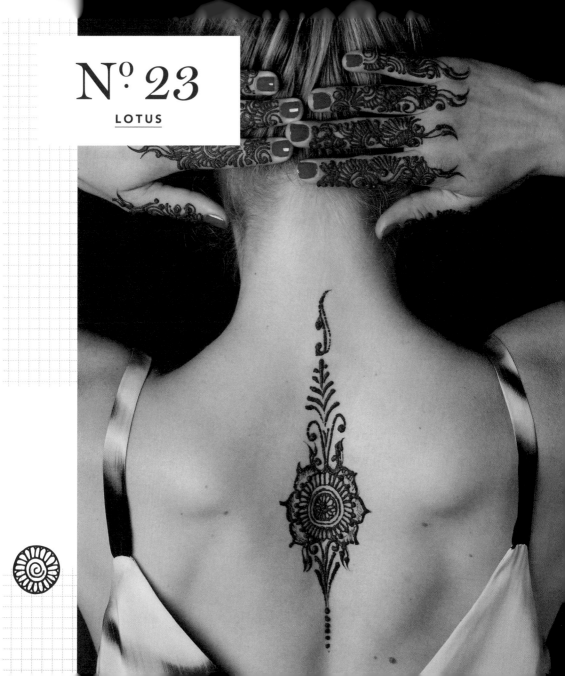

N.º 23

LOTUS

HOW TO

Ink for those outside the mainstream.

1. Draw two lines close together across the calf.

2. Draw U-shapes to create scalloped edging along the top of the upper line.

3. Roughly 2.5 cm (1 in) below the lines, draw swirls extending across the calf, parallel to the lines.

4. Draw scattered leaf, heart and club shapes around the swirls.

5. Draw two lines below the swirls to border the design. Add U-shapes to create scalloped edging below the lower lines.

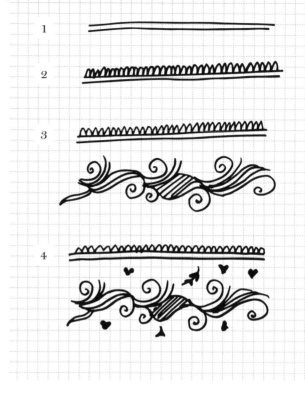

Nº 24

INDIE

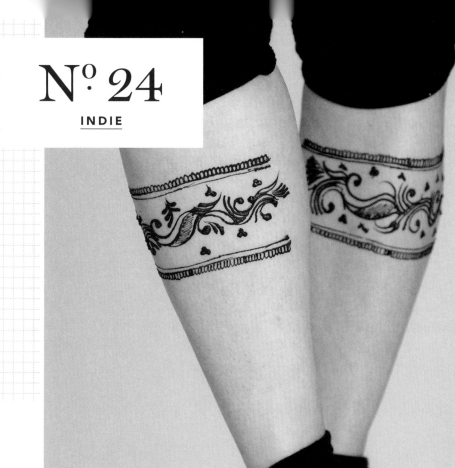

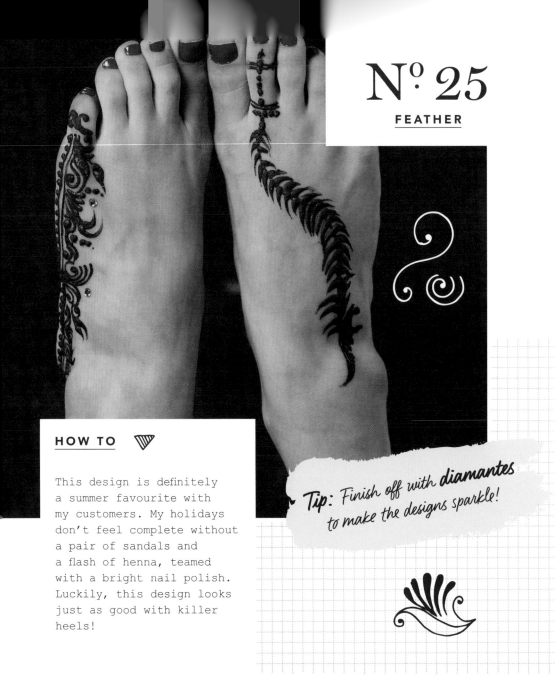

Nº 25

FEATHER

HOW TO

This design is definitely a summer favourite with my customers. My holidays don't feel complete without a pair of sandals and a flash of henna, teamed with a bright nail polish. Luckily, this design looks just as good with killer heels!

Tip: Finish off with diamantes to make the designs sparkle!

1

2

3

LEFT FOOT

1. Draw two closely spaced lines along the edge of the foot, then draw scalloped U-shapes across the upper line.

2. Within your design area, draw swirls, petals and feather shapes, using the scalloped line you have created as a guide.

3. Continue from the toe down to the heel until you have covered the entire length of the foot.

1

2

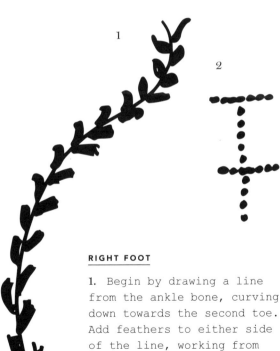

RIGHT FOOT

1. Begin by drawing a line from the ankle bone, curving down towards the second toe. Add feathers to either side of the line, working from the toe down to the ankle.

2. Add a toe ring and cross shape to the second toe.

HOW TO ▽

I came up with this design when I was walking down a garden path, surrounded by roses…

1. Draw a trail of petals curving from the top of the shoulder and down the arm.

2. Draw a line of closely spaced dots above the trail of petals, following the shape of the trail.

3. Draw roses on either side of the trails, beginning from the centre and flicking outwards.

3

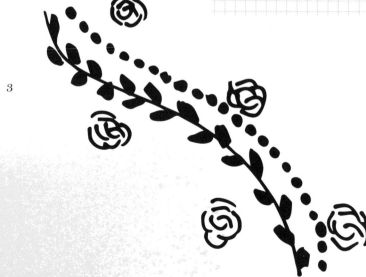

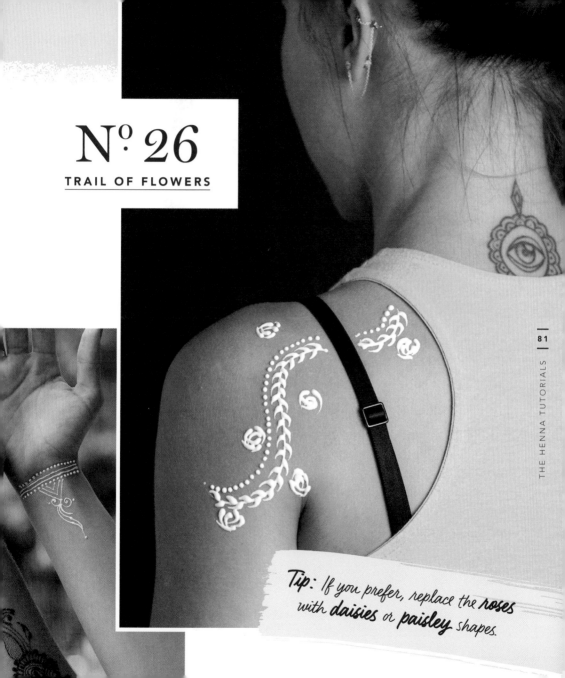

N.º 26

TRAIL OF FLOWERS

THE HENNA TUTORIALS

Tip: If you prefer, replace the **roses** with **daisies** or **paisley** shapes.

HOW TO ▼

This cuff is bold and stylish, and goes great with a simple outfit when you want your henna to be a real focal point. I was inspired by the cuffs on the runway at Chanel, Fendi and Chloé.

1. Draw a straight line across the wrist, then draw another line decorated with dots around 5–7 cm (2–3 in) below it.

2. Double up each line, then draw scalloped edging above both straight lines. Decorate the top row of scalloped edging with dots.

3. Draw a small petal shape in the middle of the cuff, and outline with larger petal shapes.

1 —————— 3

2

4

5

N° 27
PETAL CUFF

Tip: Keep an eye on **runway shows** — there are always some great **trends** to incorporate and keep your henna cutting-edge!

4. Fill in the space around the petal, inside the cuff, with small swirls.

5. Add a small vertical line of dots leading off from the cuff towards the hand. Add more lines and dots above the cuff, with a flourish of swirls for extra decoration.

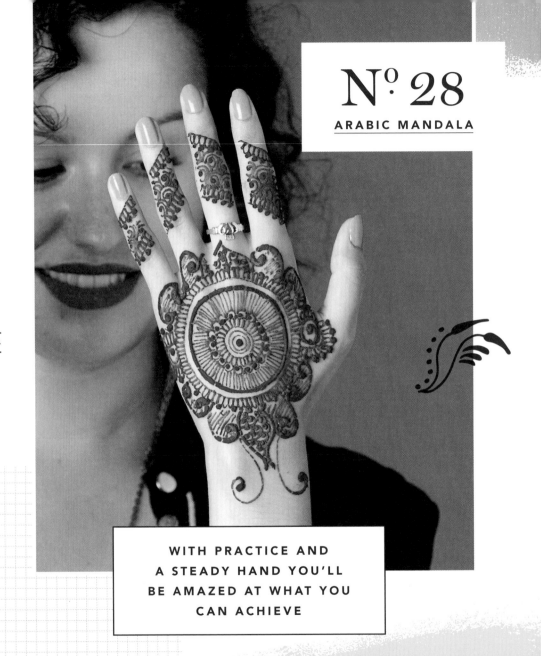

N.º 28
ARABIC MANDALA

WITH PRACTICE AND
A STEADY HAND YOU'LL
BE AMAZED AT WHAT YOU
CAN ACHIEVE

HOW TO ▼

Mandalas represent wholeness – and personally I don't feel complete without a gorgeous henna design!

1. Begin by drawing a dot in the centre of the hand, then draw three small concentric circles around it.

2. Draw scalloped U-shapes around the outside of the largest circle. Draw small swirls around the design.

3. Draw a larger circle around the design, leaving about 1 cm (½ in) of space around it. Fill in the space with very fine lines extending outwards from the design to the edge of the circle. Leaving a small gap, draw a large circle around the entire design.

4. Draw more scalloped U-shapes around the design. Finish with large petals, filling in with swirls and shading. Add two large swirls at the bottom of the mandala.

5. Complete the look by creating the finger design. Draw blocks of swirls extending in a V-shape across all four fingers.

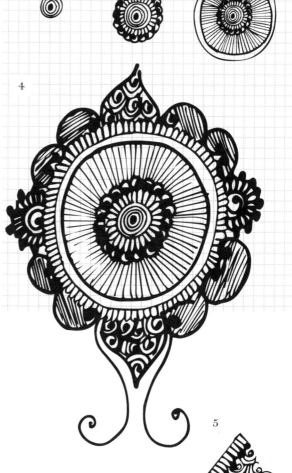

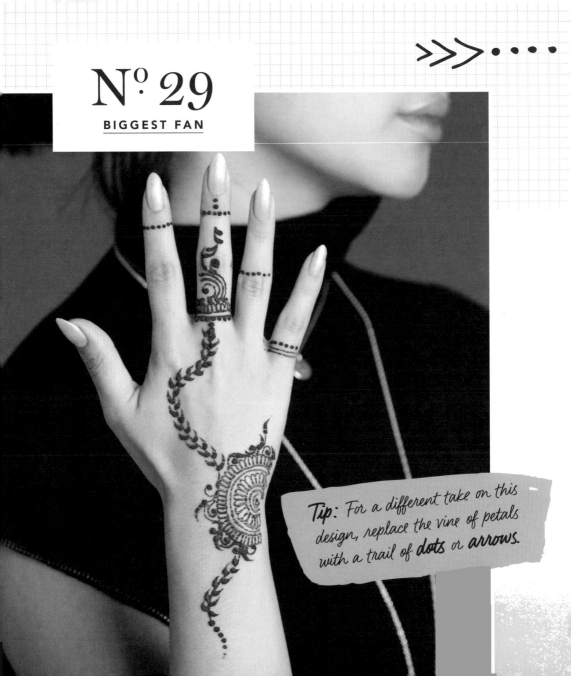

Tip: For a different take on this design, replace the vine of petals with a trail of **dots** or **arrows**.

1

3

5

4

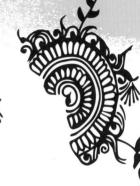

HOW TO ▼

This one is great for gigs – show you're a true fan!

1. Draw a small swirl on the outer edge of the wrist where you wish the design to begin. Begin building a semicircle around the design, starting with three small arcs.

2. Outline the largest arc using scalloped U-shapes.

3. Close off the semicircle using two solid arcs. Outline the whole semicircle using scalloped U-shapes as in step 2 to create your fan. Close off the U-shapes with a solid arc.

4. Draw leafy swirls around the edges of your fan.

5. Draw a vine of petals extending from the bottom edge of your fan, down towards the inner edge of your arm. Draw a vine from the centre of your fan up to the base of your middle finger.

6. Draw rings and shapes on the fingers, taking inspiration from the designs on pages 38–39.

6

THE HENNA TUTORIALS

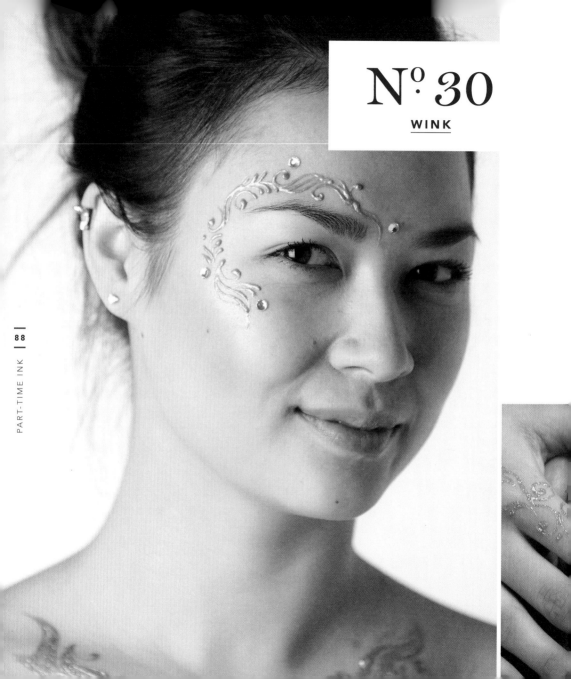

1

2

3

HOW TO ▽

One of the coolest ways to wear henna.

1. Draw graceful swirls starting from the top of the bridge of the nose and extending above and along the eyebrow.

2. Carefully continue the swirl, curving around the eye.

3. Finish the swirls in a delicate curve ending at the cheekbone. If you like, add gems for extra sparkle!

Tip: Using **glitter** henna or **body paint** on the face creates a surprisingly **delicate** look.

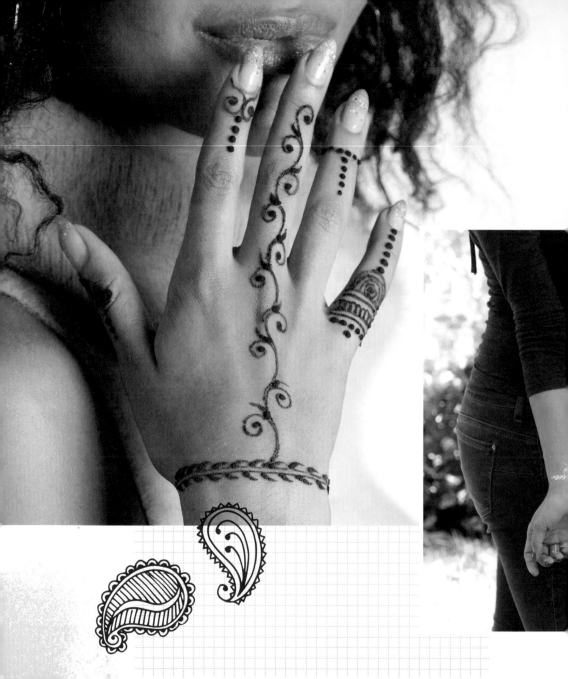

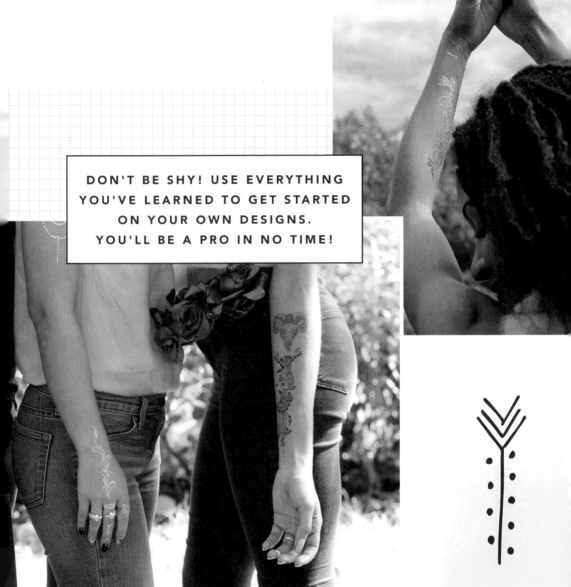

DON'T BE SHY! USE EVERYTHING
YOU'VE LEARNED TO GET STARTED
ON YOUR OWN DESIGNS.
YOU'LL BE A PRO IN NO TIME!

About the author

Pavan Ahluwalia has immersed herself into the world of henna and design from the tender age of seven, and is now one of the leading henna artists in the UK.

Pavan holds the Guinness World Record for the fastest henna artist. In 2012, she painted a staggering 511 individually designed armbands in just 1 hour – beating her own previous 2008 record of 314 armbands by a mind-blowing 197 armbands.

She has worked with celebrities and brands such as Selfridges, Harrods, Sky and the BBC on various high-profile projects. A self-taught henna artist, Pavan doesn't only keep up to date with the latest design trends, she creates them. Working with a multicultural clientele, Pavan creatively incorporates details like glitter, diamante and even coloured body paint into her bespoke designs, transforming her intricate patterns into breathtaking works of art.

Pavan carefully consults with her clients and coordinates her designs to complement outfits and jewellery. She loves to share her artwork on Instagram and has over 20,000 followers.

Experimenting with applying henna designs to shoes, candles and textiles, Pavan is a true original!

Acknowledgements

Thank you to my parents, who have been the backbone to my business and pushed me to achieve the Guinness World Record. Thank you to my sisters and brother, who help me make endless henna cones, help at many exhibitions and support every crazy idea of mine.

Thank you to Guinness World Records for such an amazing title that really helped to launch my career.

Thank you to my friend Preeya for letting me try out my wacky ideas and always encouraging me to go wild. All those whom I have had the pleasure to work with and who encouraged me to keep going — Pedro you always did and continue to do this.

Thank you Topshop for my big break and my first henna bar and Selfridges for turning this into a dream come true. Elizabeth, you really made it happen and I am so grateful.

To the whole team and managers at Selfridges and of course my girls — you are the face of the henna bar and your expertise keeps us alive.

Thank you Kate, Jacqui, Kajal, Michelle and Hannah for bringing the book to life.

Thank you to all the models — the book wouldn't be the same without you.

Last, but by no means least, thank you to my Amandeep, without whom there would be no Pavan Henna Bar. Your patience and work ethic inspire me every day.

Pavan xxxx

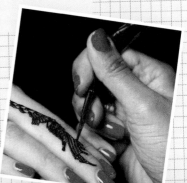

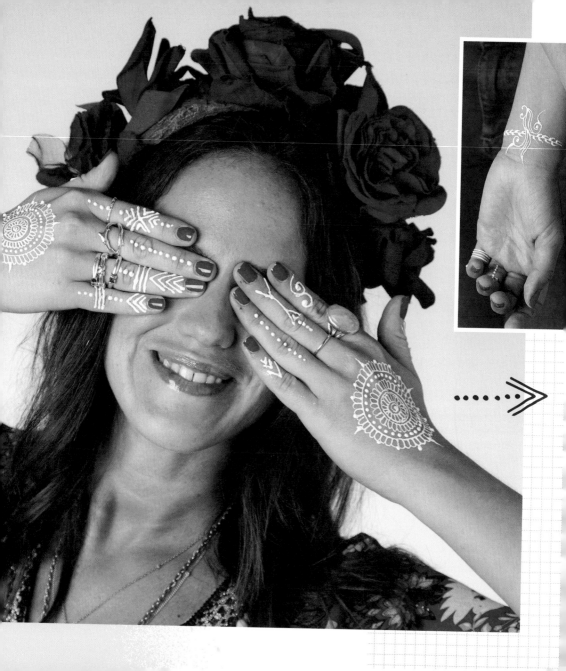

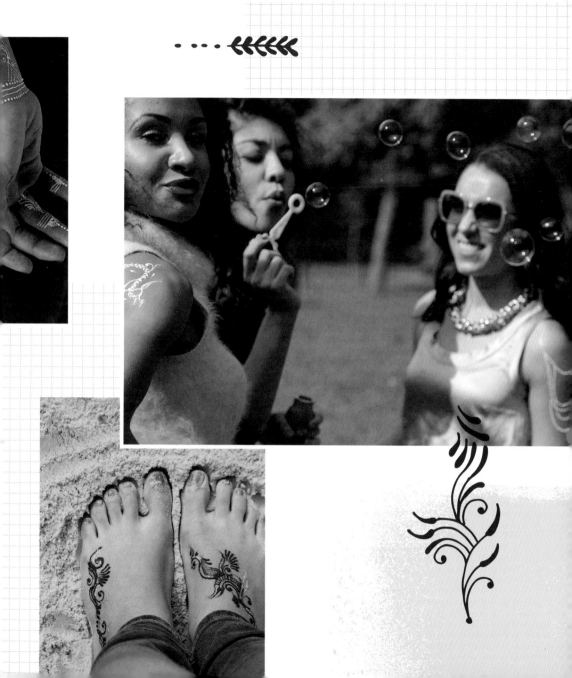

Part-Time Ink by Pavan Ahluwalia

First published in 2016 by Hardie Grant Books

Hardie Grant Books (UK)
52-54 Southwark Street
London SE1 1UN
hardiegrant.co.uk

Hardie Grant Books (Australia)
Ground Floor, Building 1
658 Church Street
Melbourne, VIC 3121
hardiegrant.com.au

British Library Cataloguing-in-Publication Data. A catalogue
record for this book is available from the British Library.

ISBN: 978-1-78488-035-4

Publisher: Kate Pollard
Senior Editor: Kajal Mistry
Editorial Assistant: Hannah Roberts
Photographer: Jacqui Melville
Art Direction: Michelle Noel
Colour Reproduction by p2d
Retouching: Butterfly Creative Services

Printed and bound in China by 1010

10 9 8 7 6 5 4 3 2 1